Adult Coloring Book

Lion & Lionese

Bambang Wisudyantoro

cannonzhooter@gmail.com

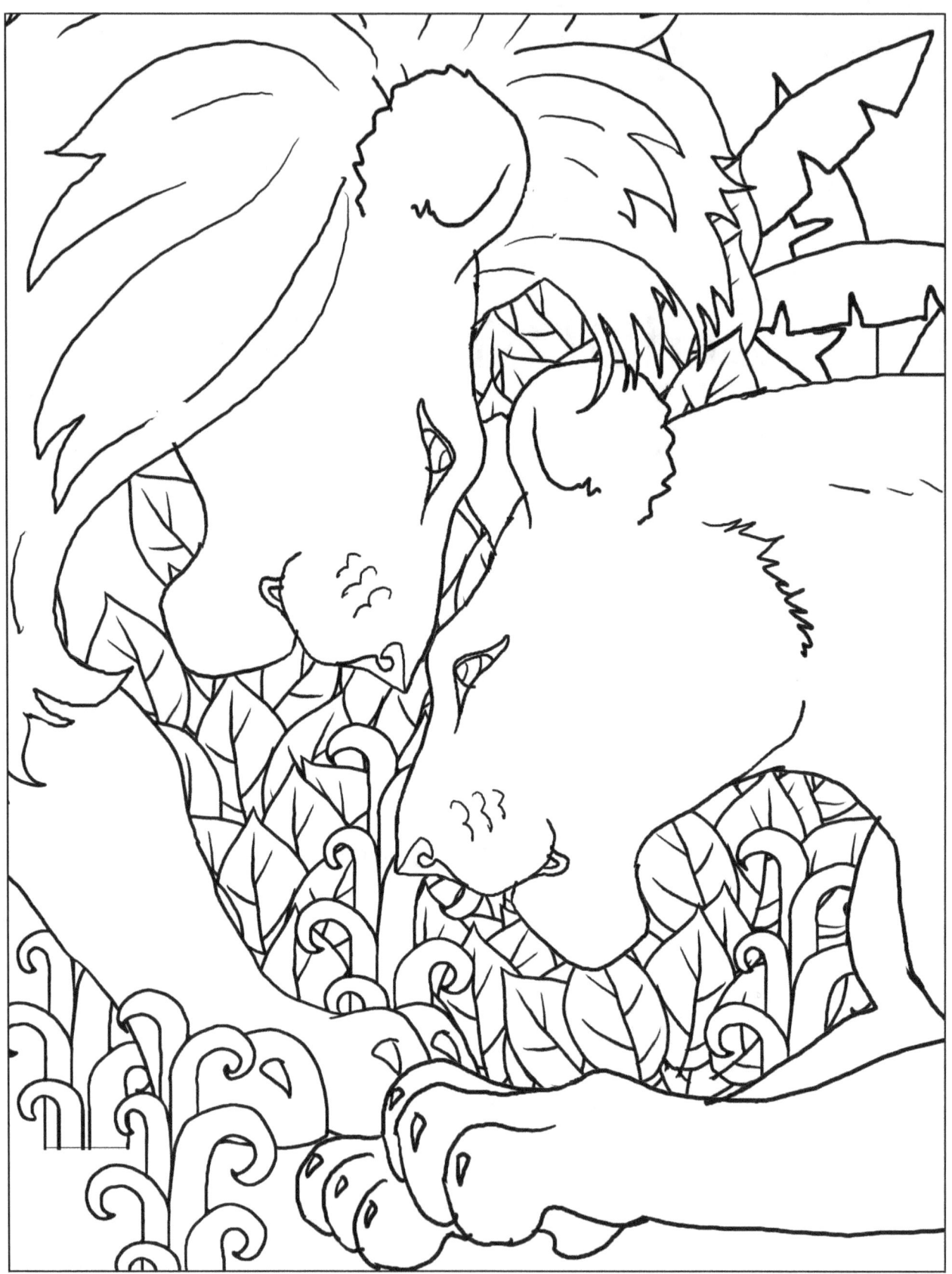

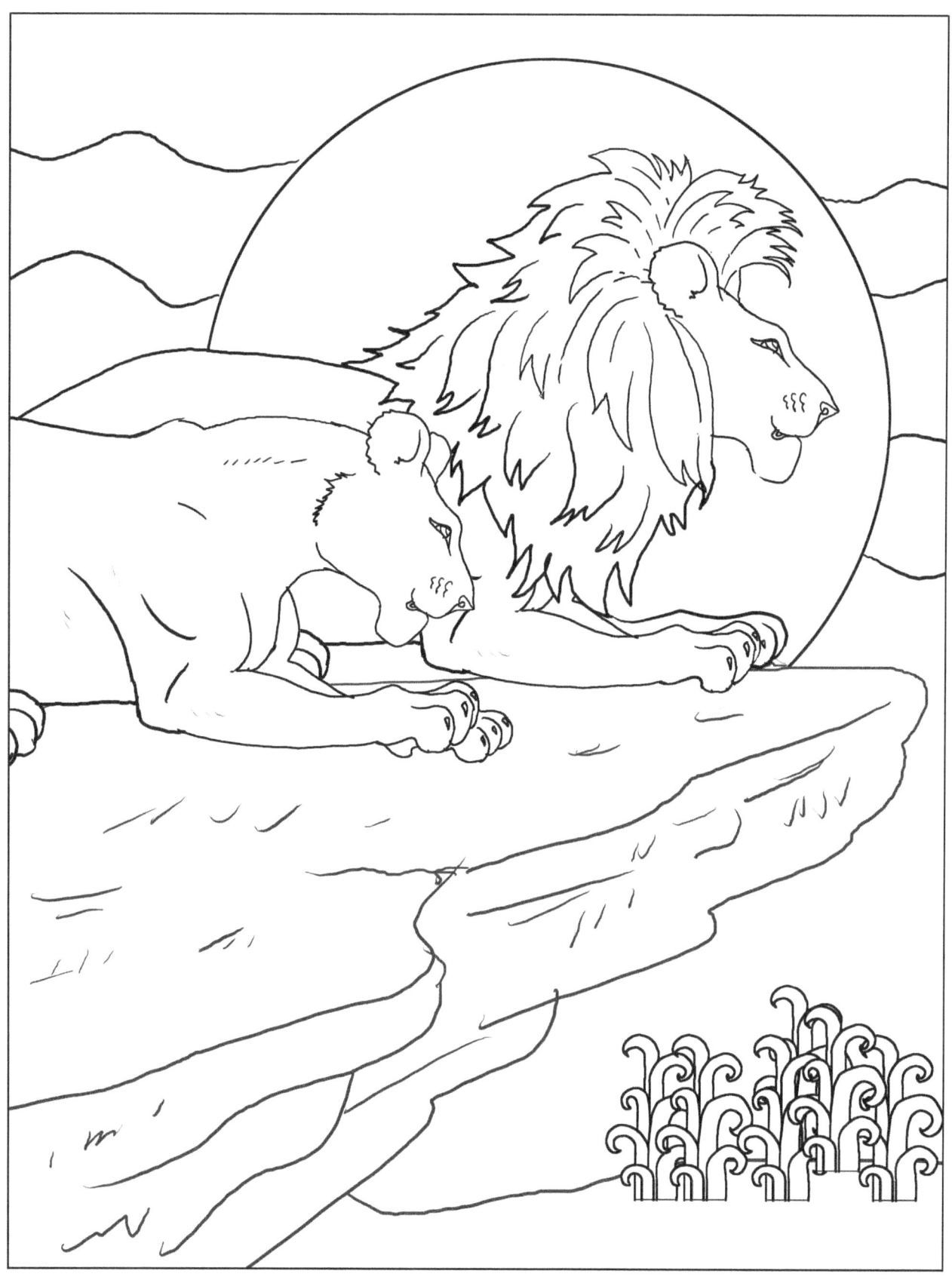

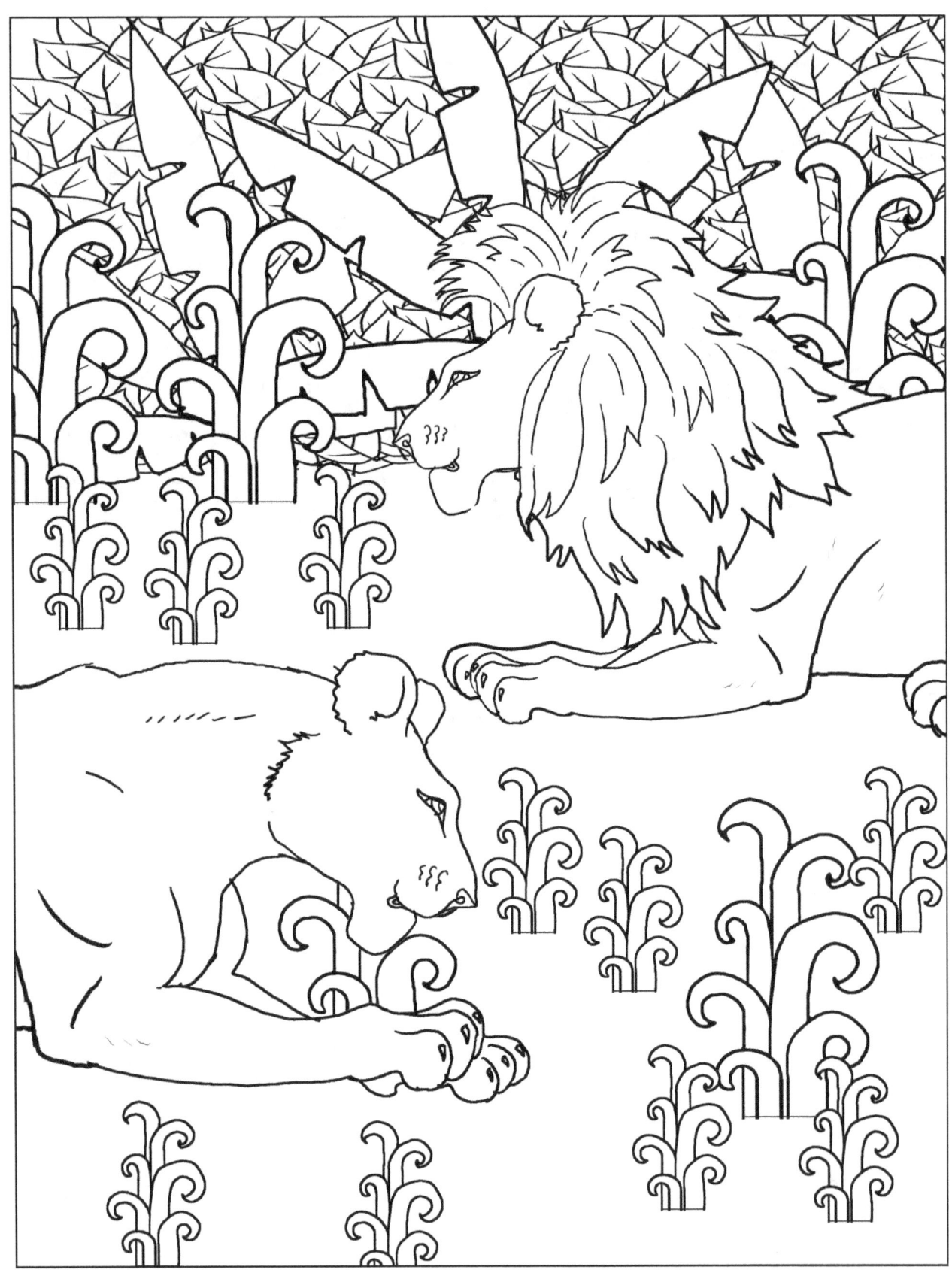

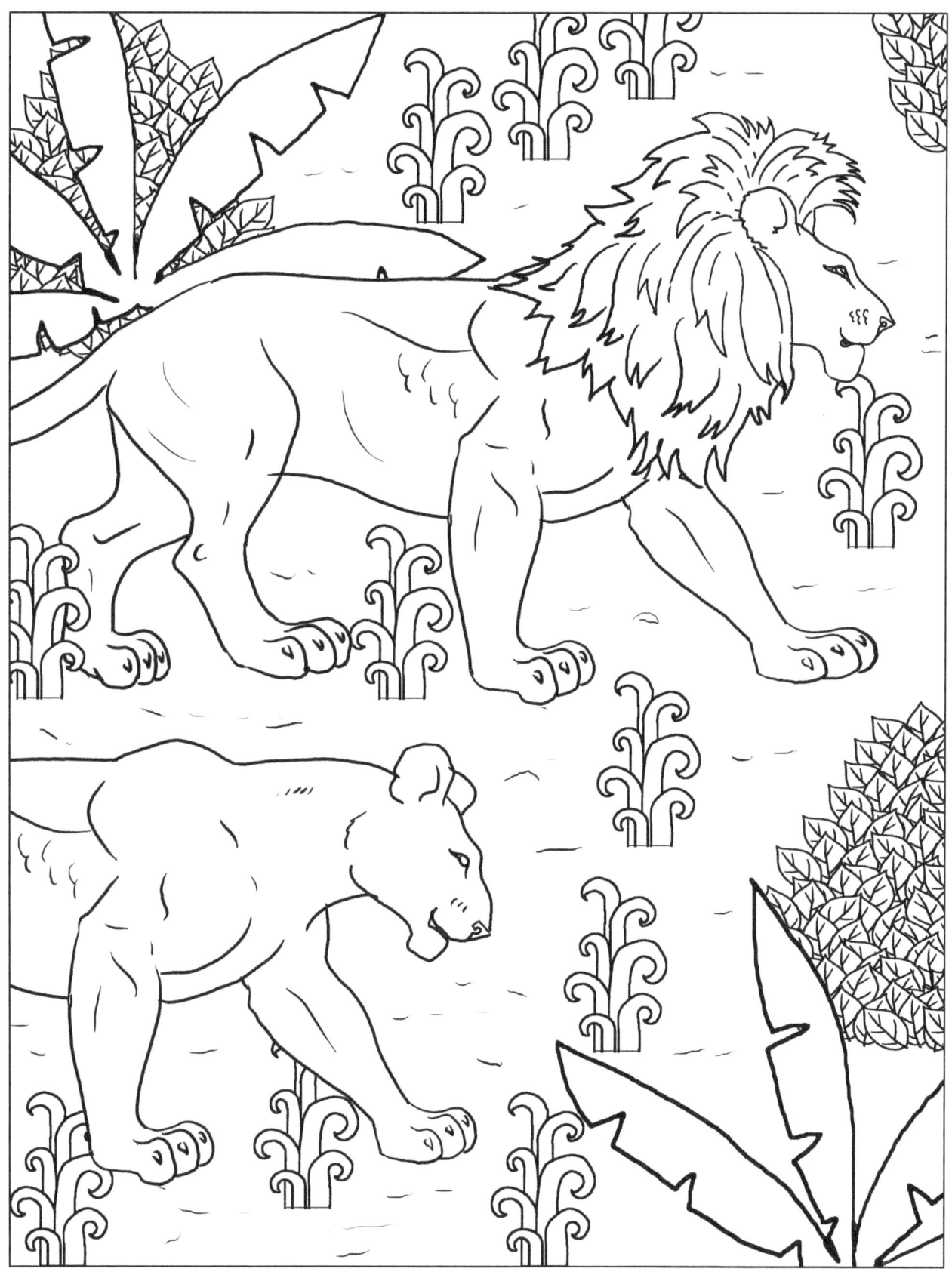

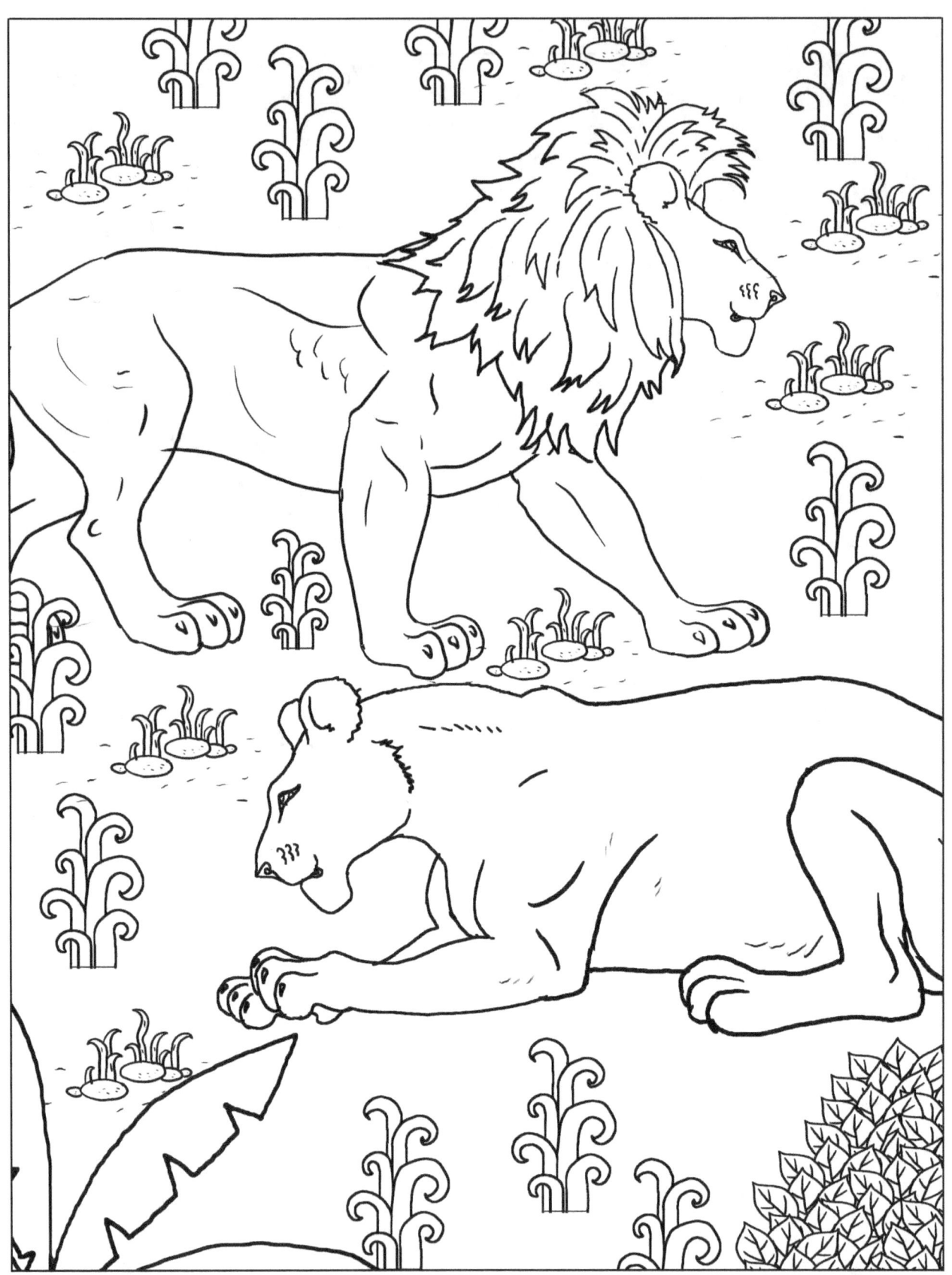

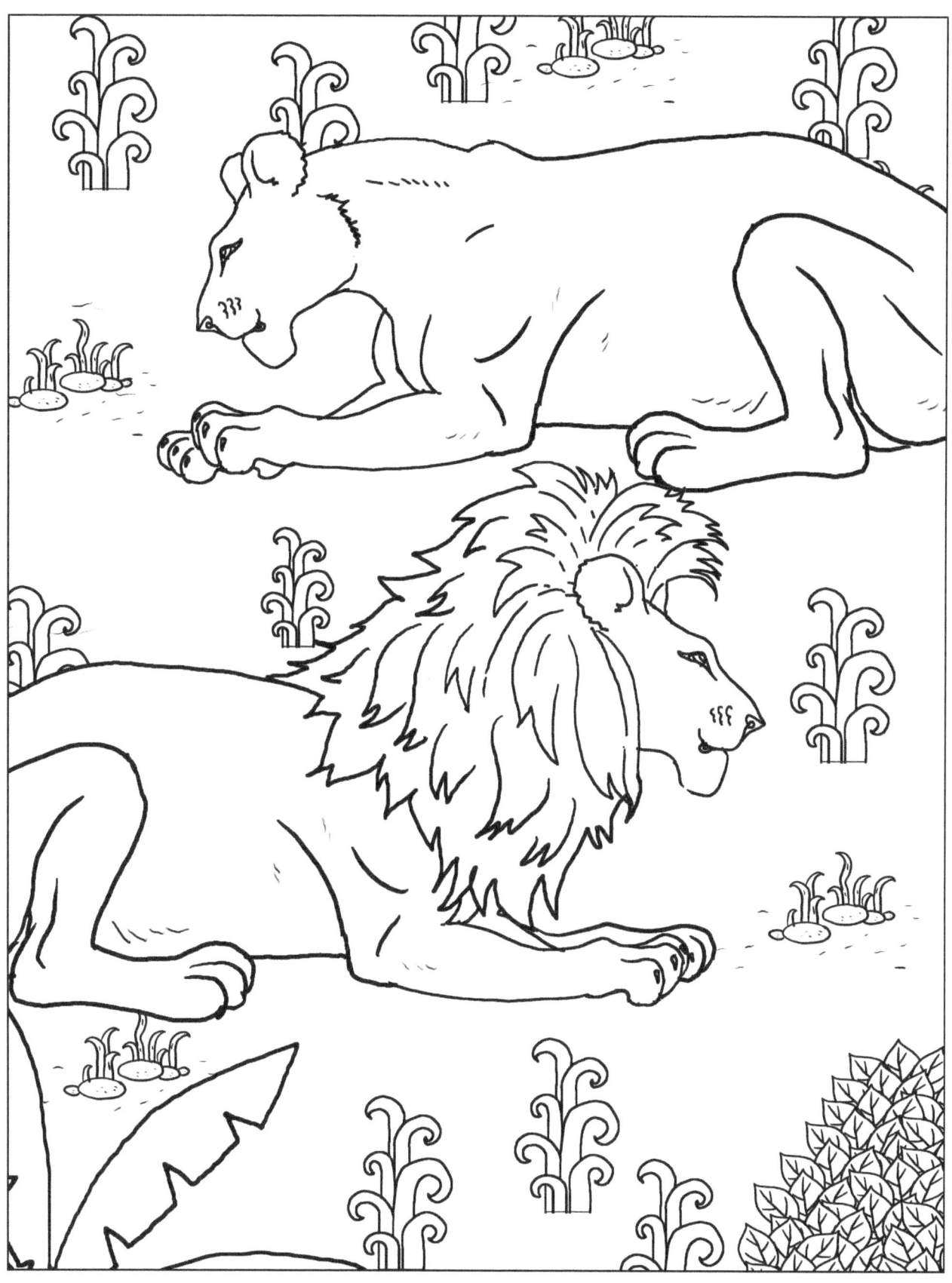

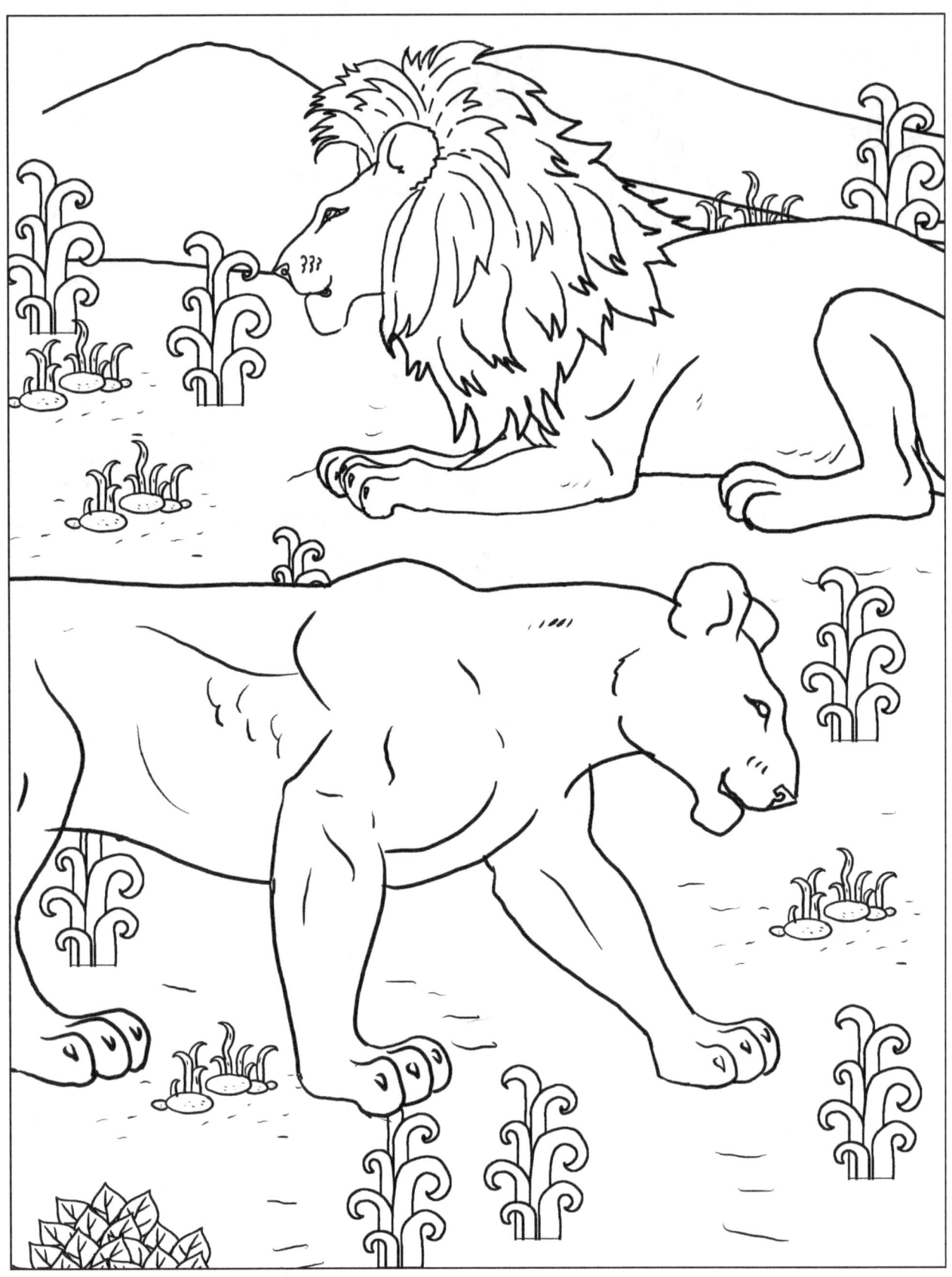

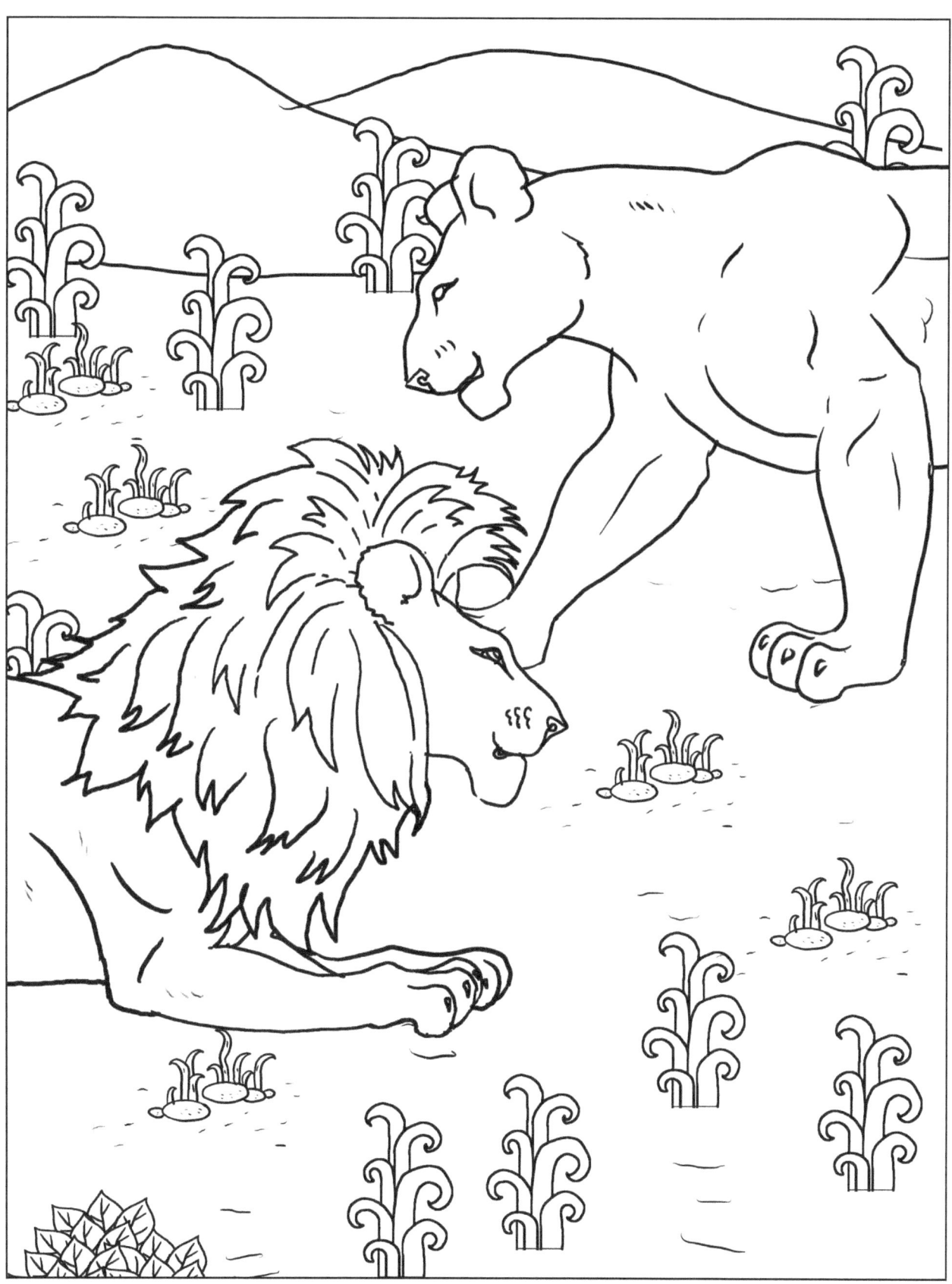

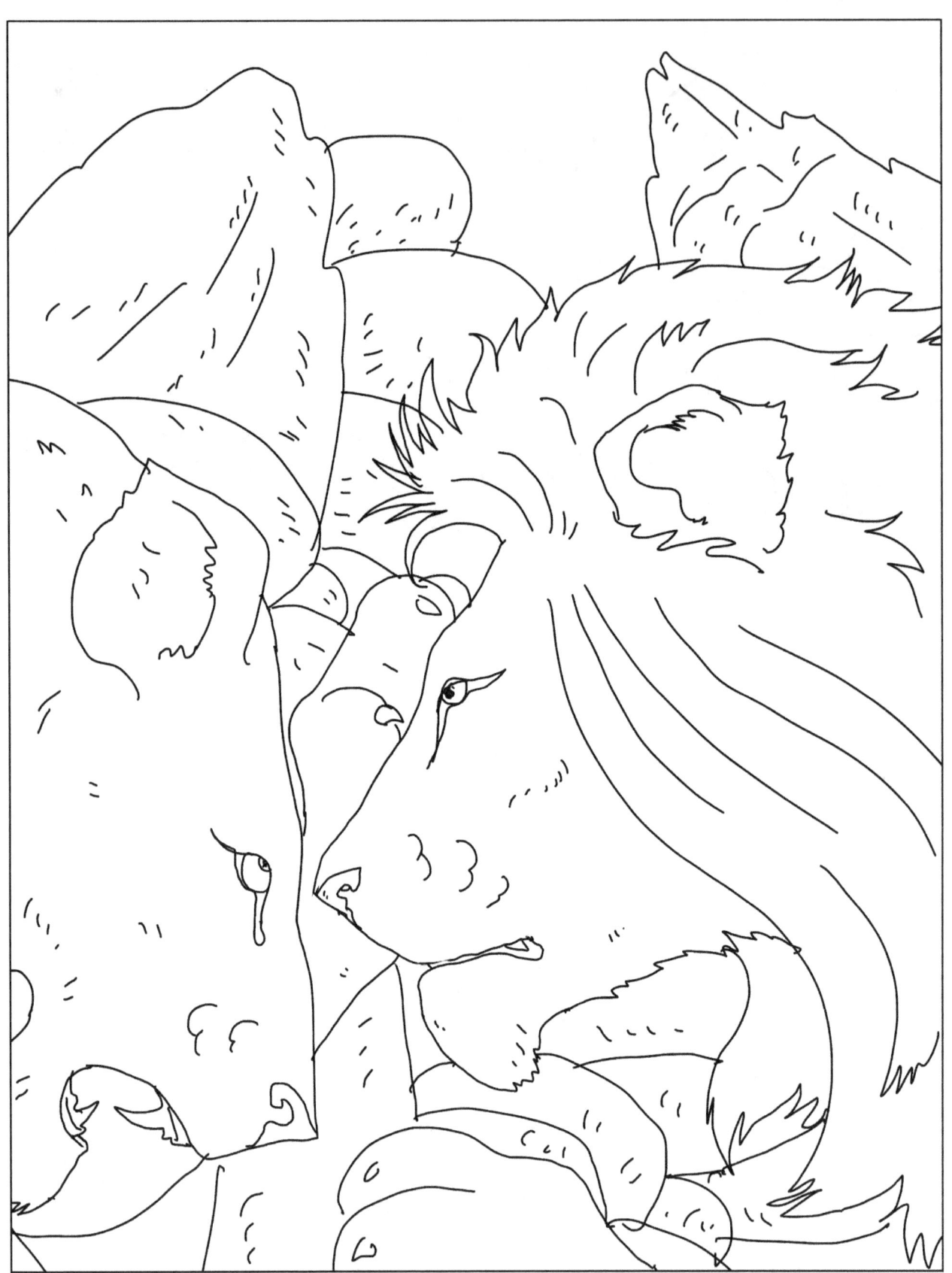

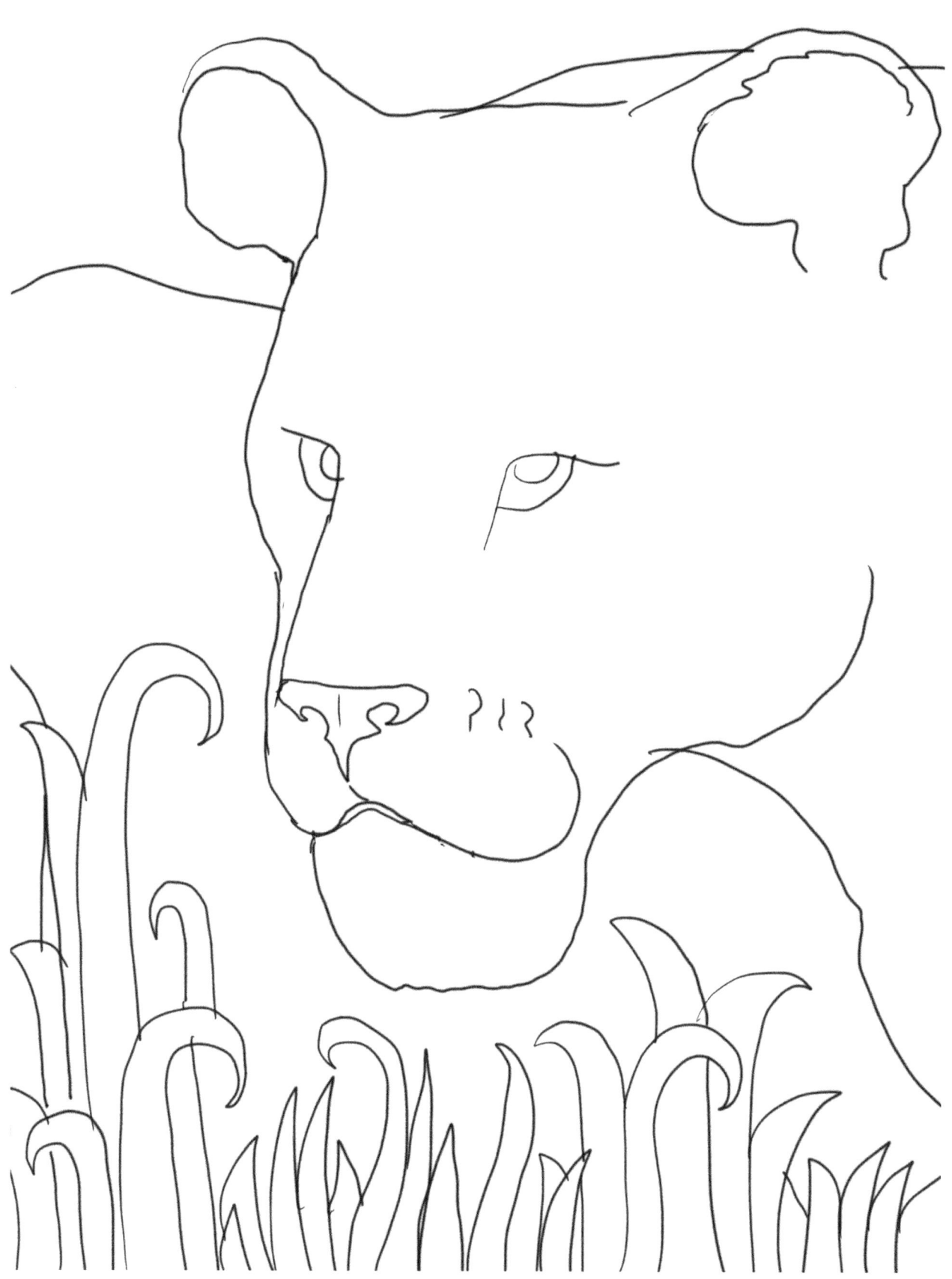

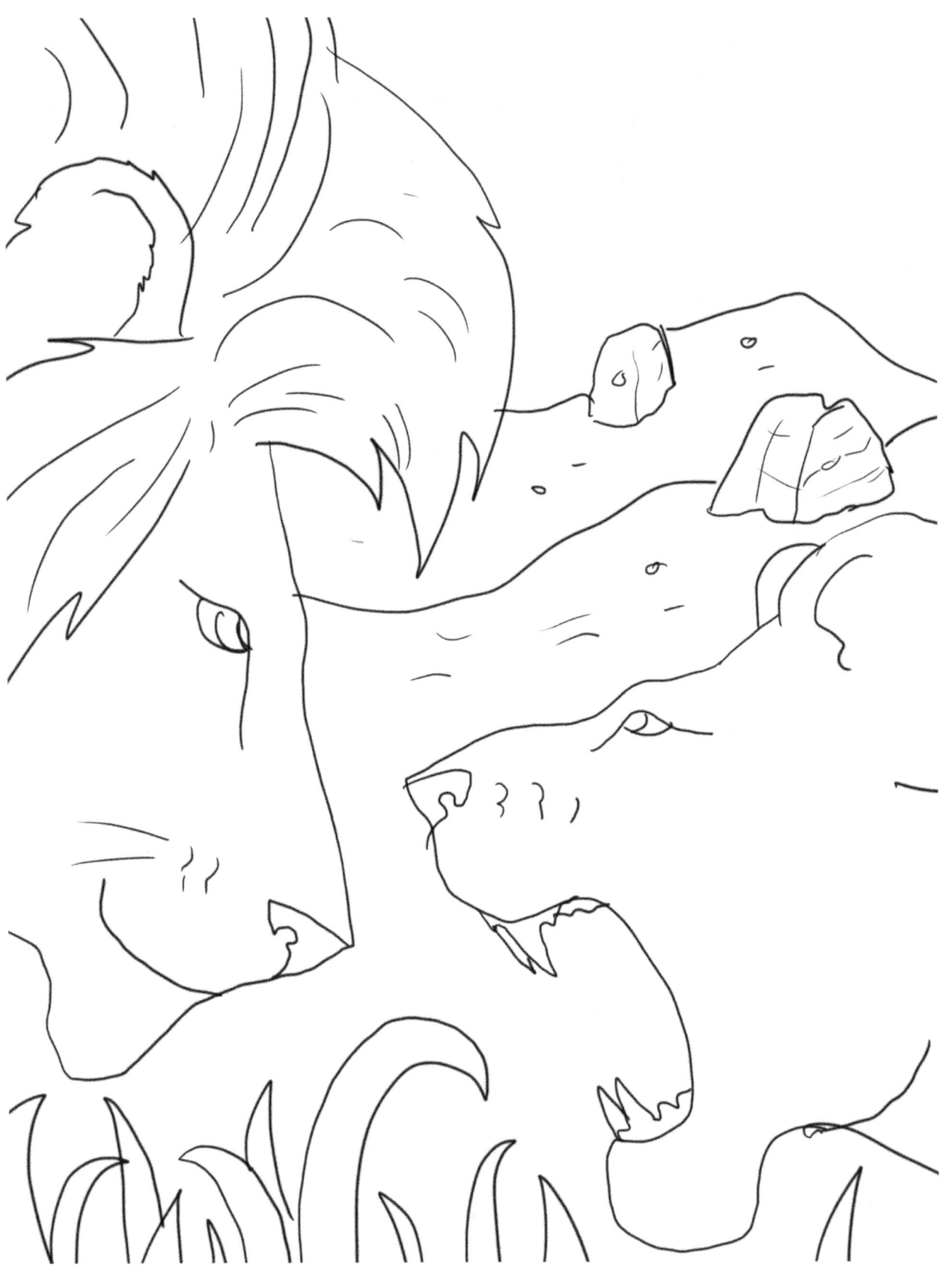

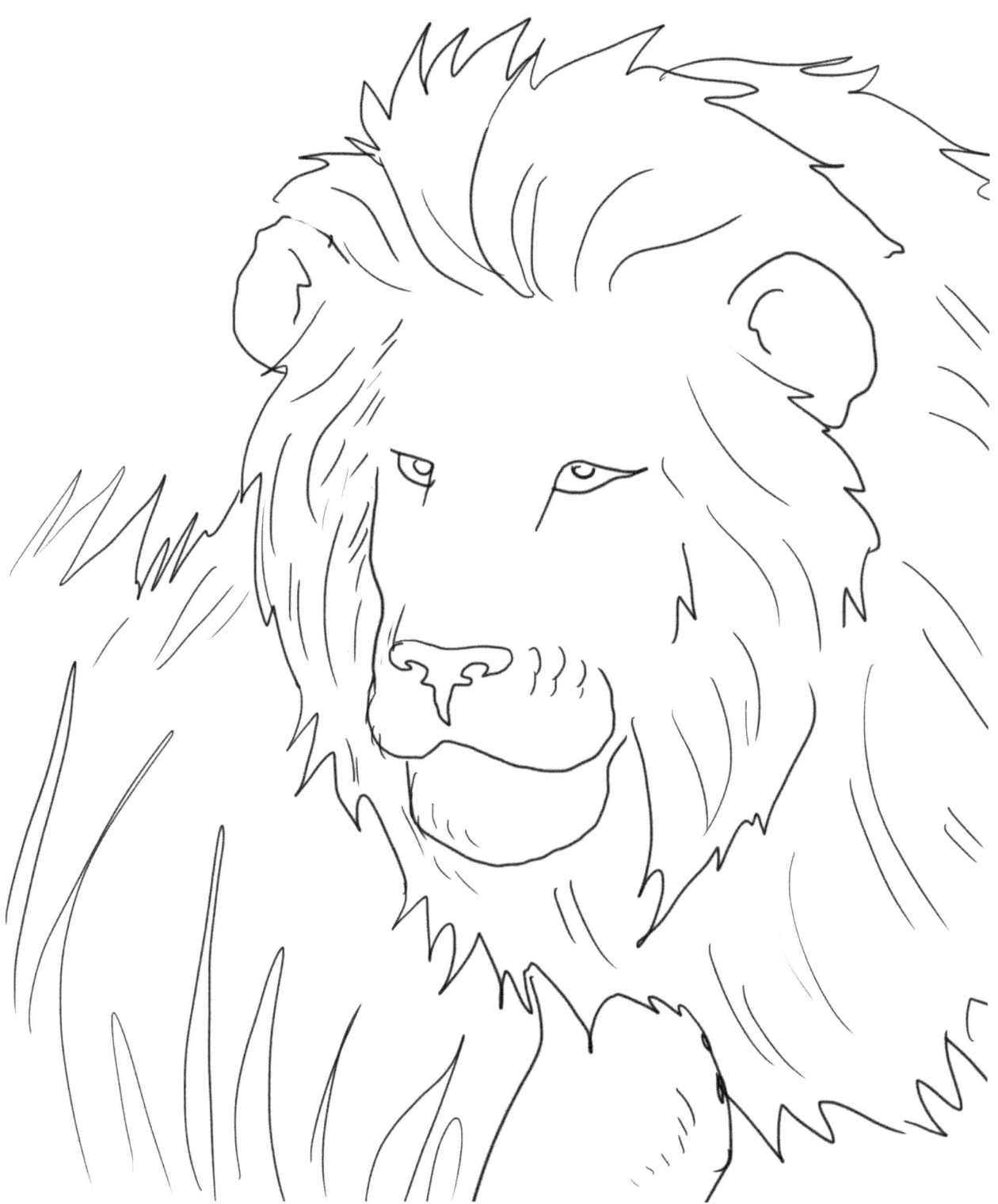

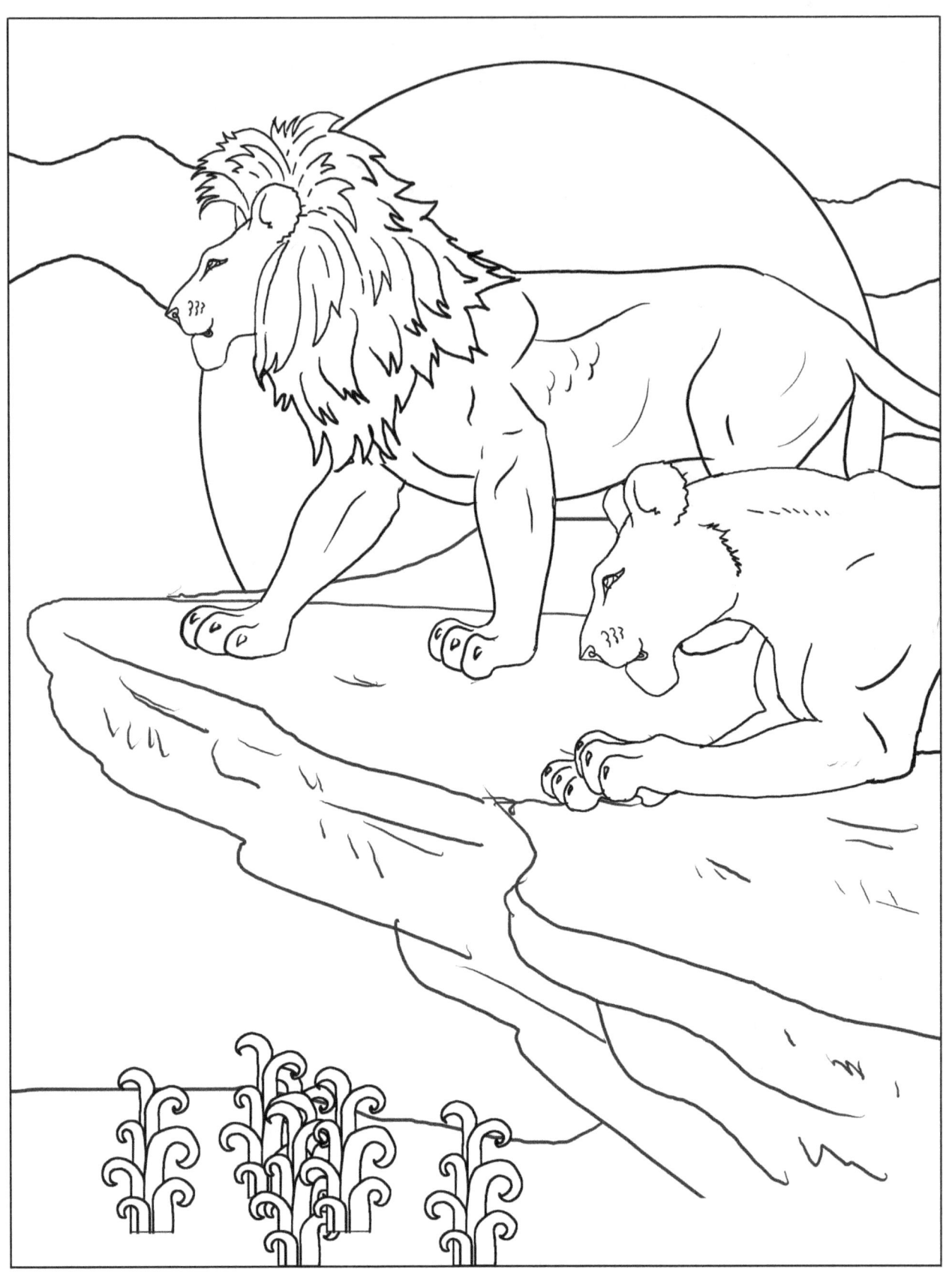

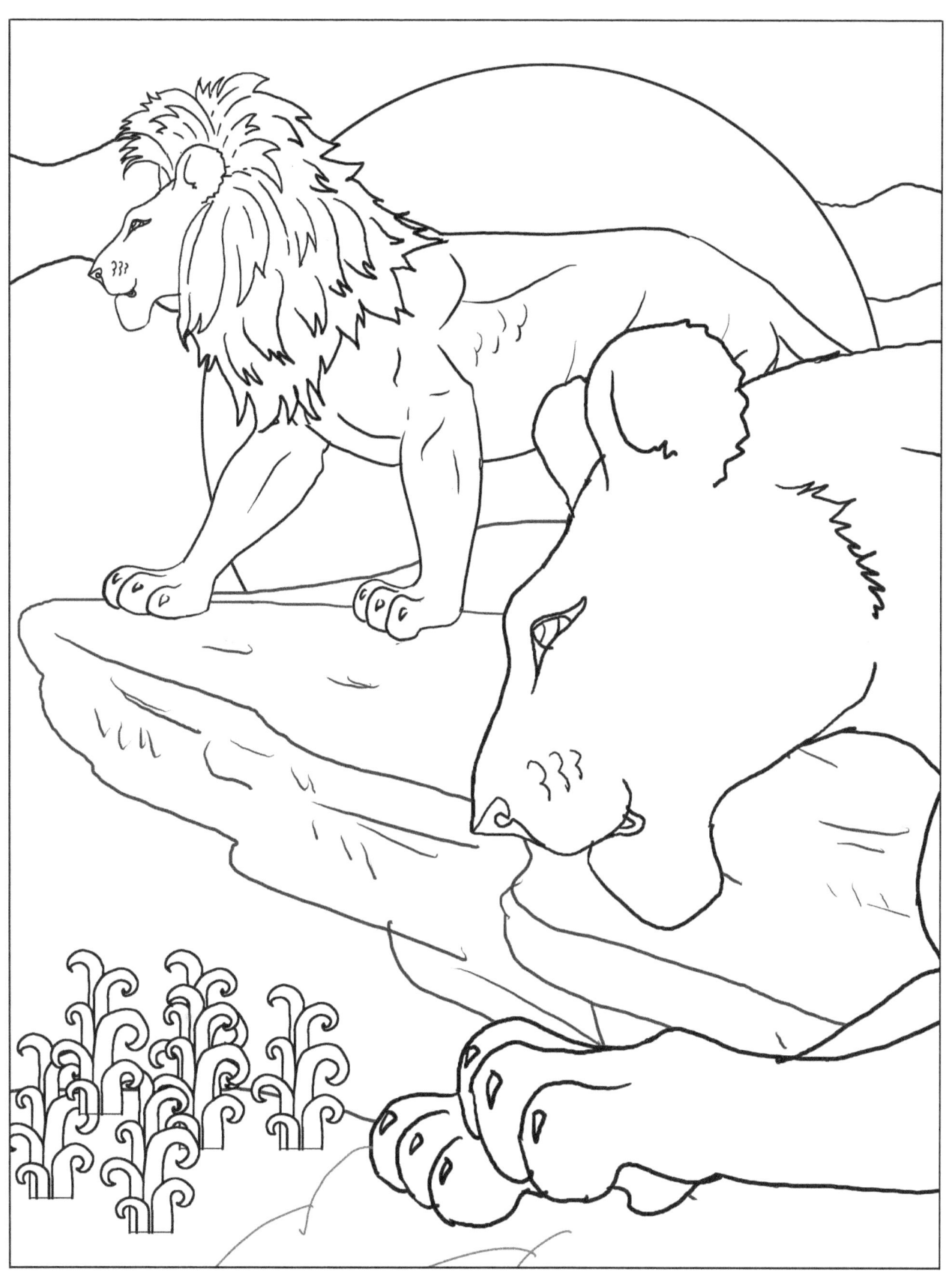

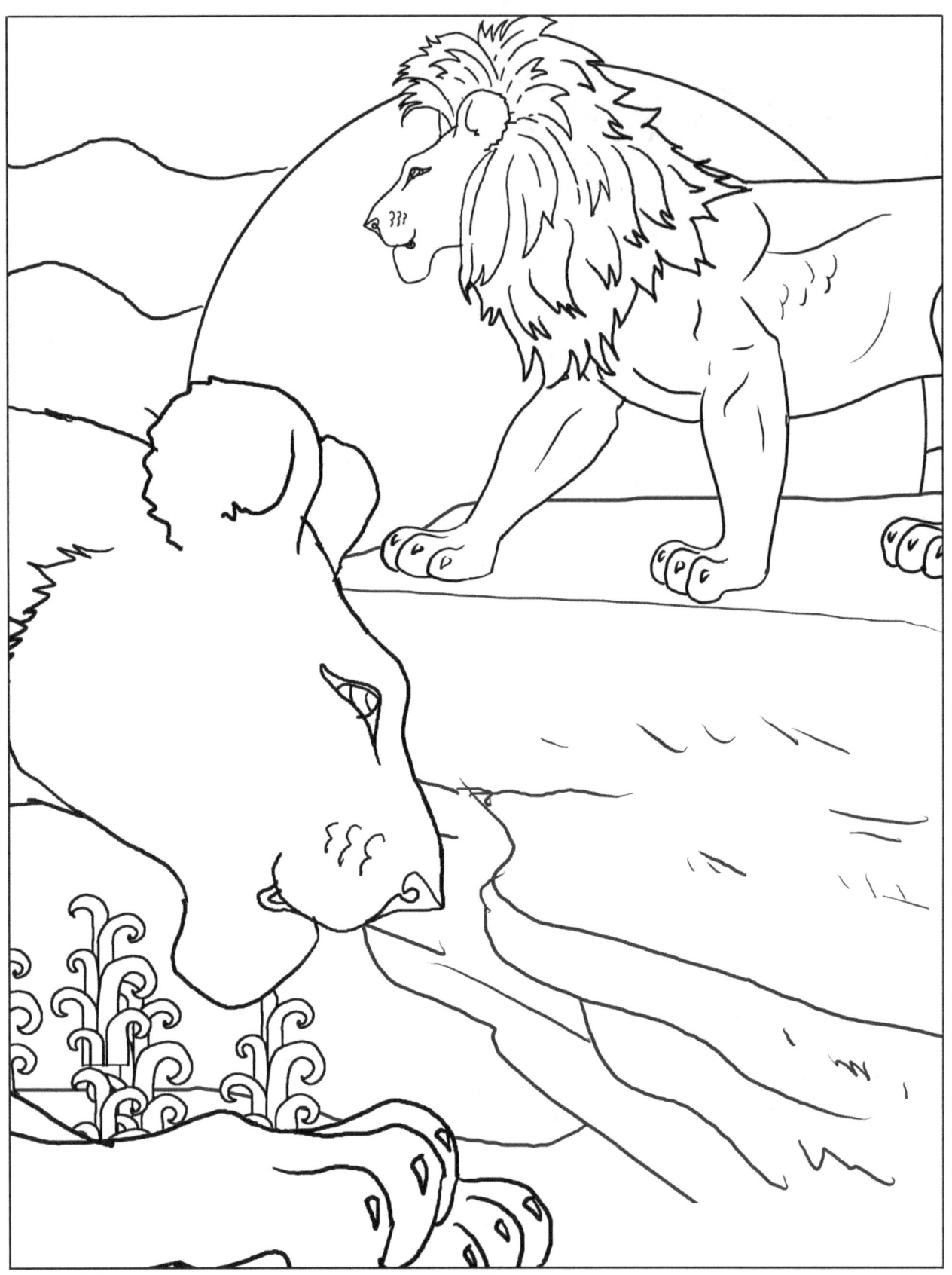

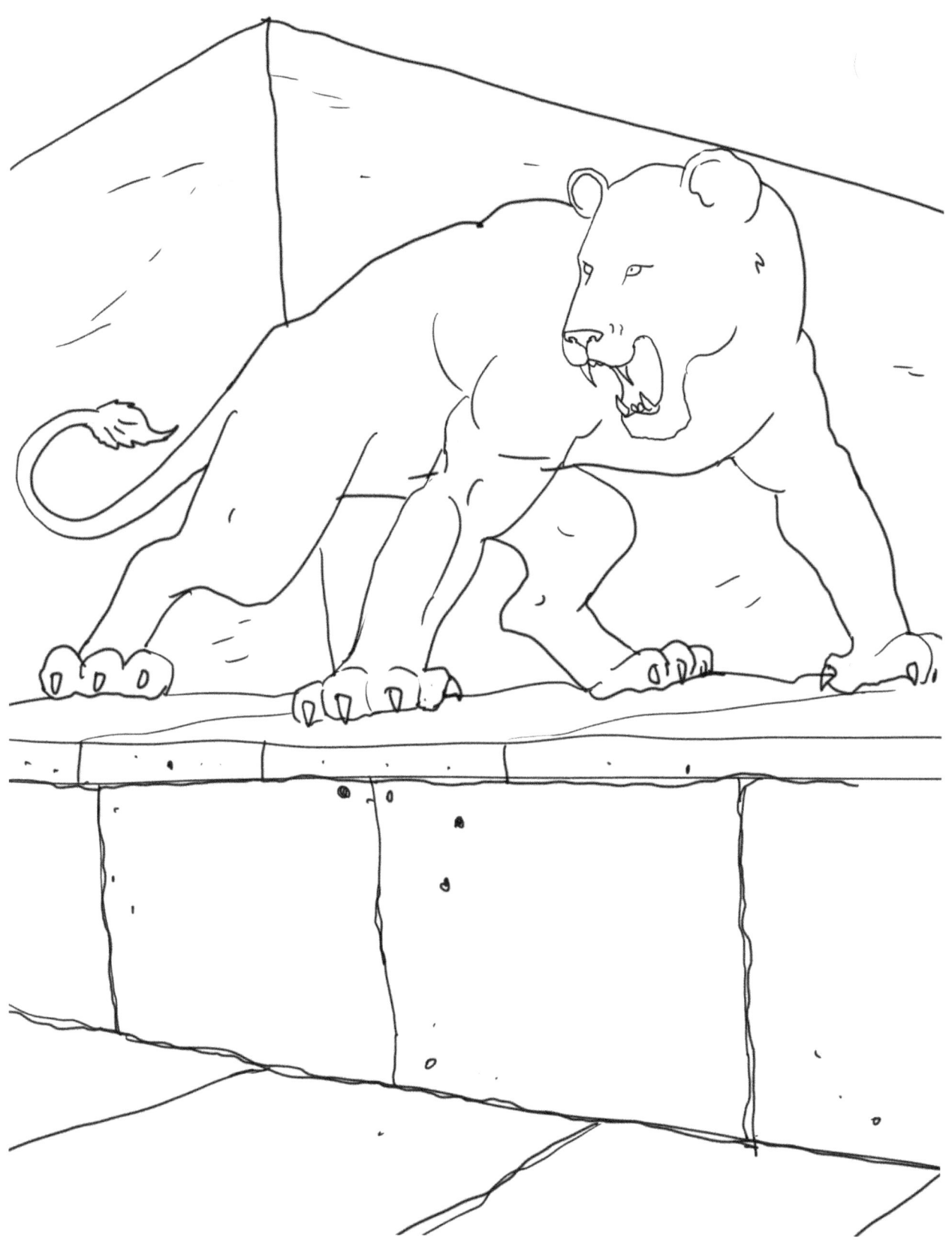

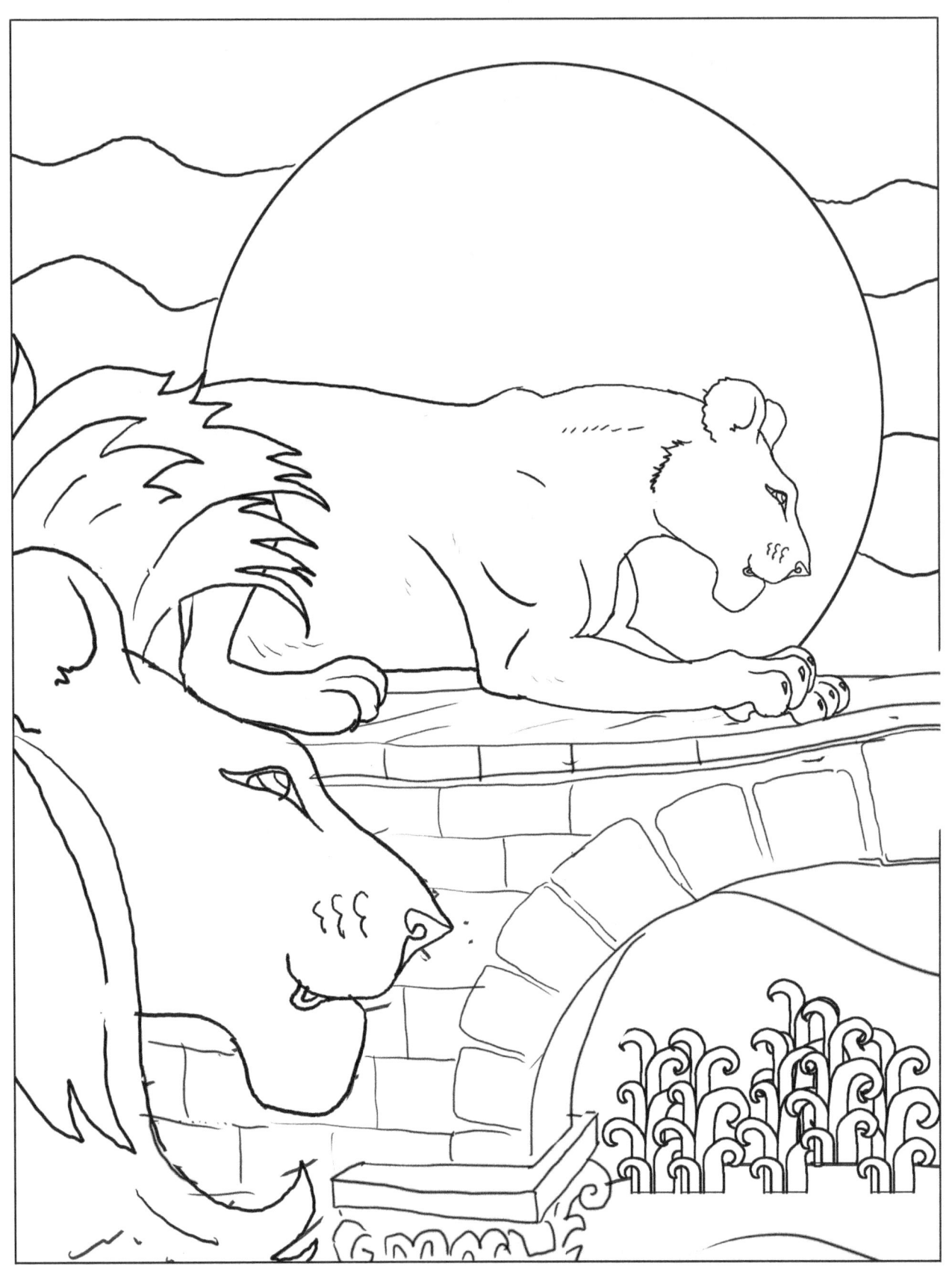

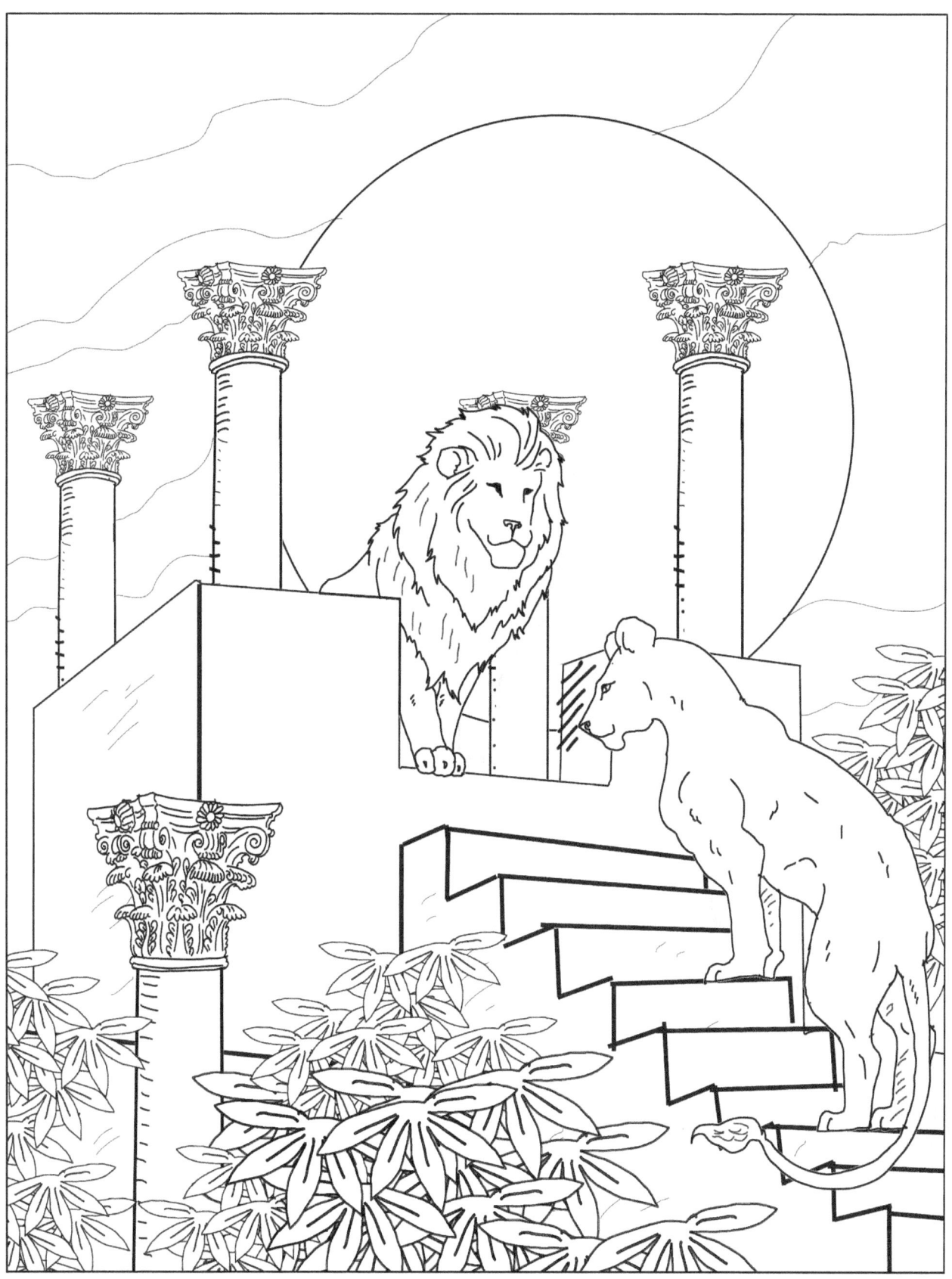

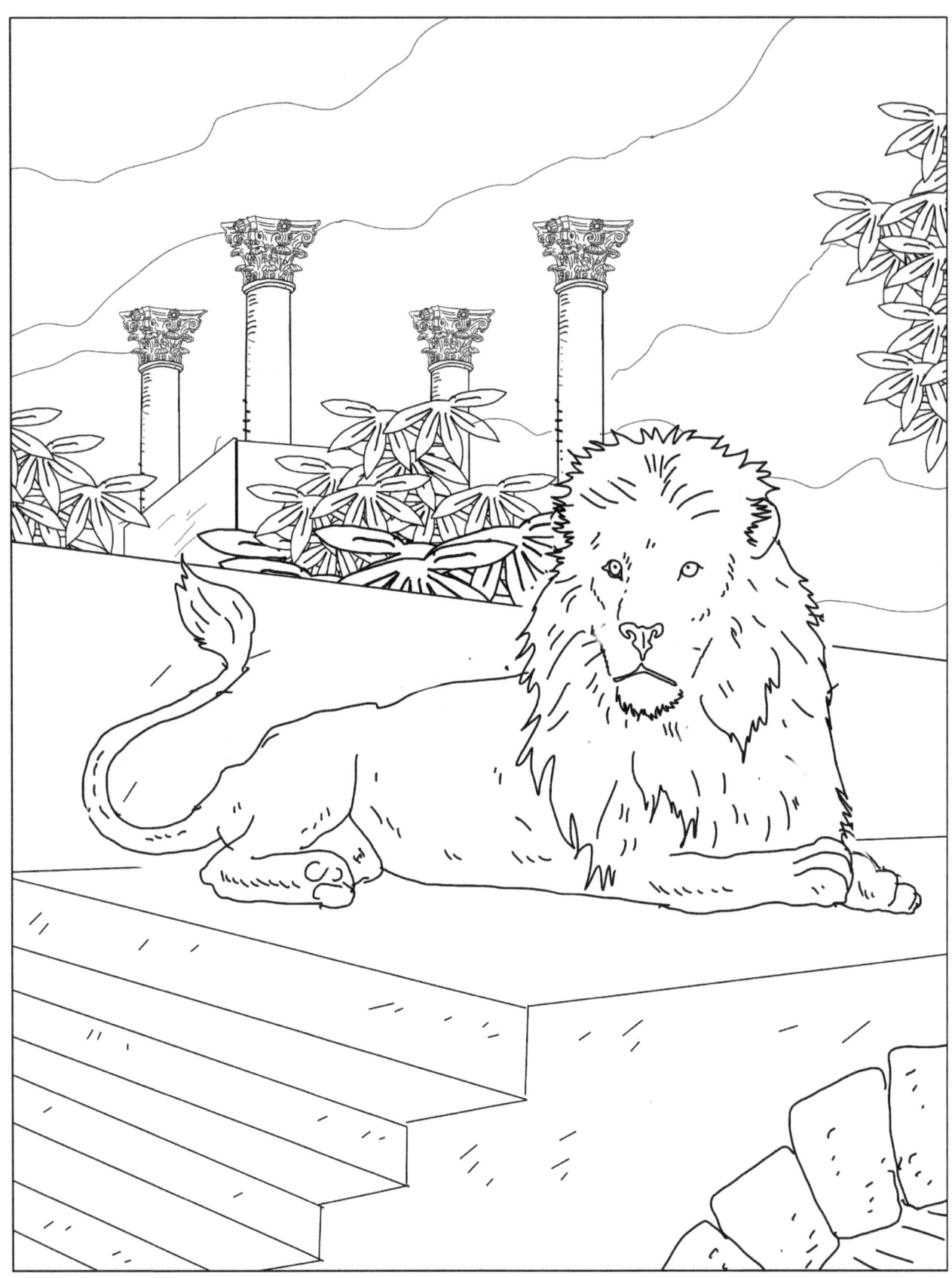

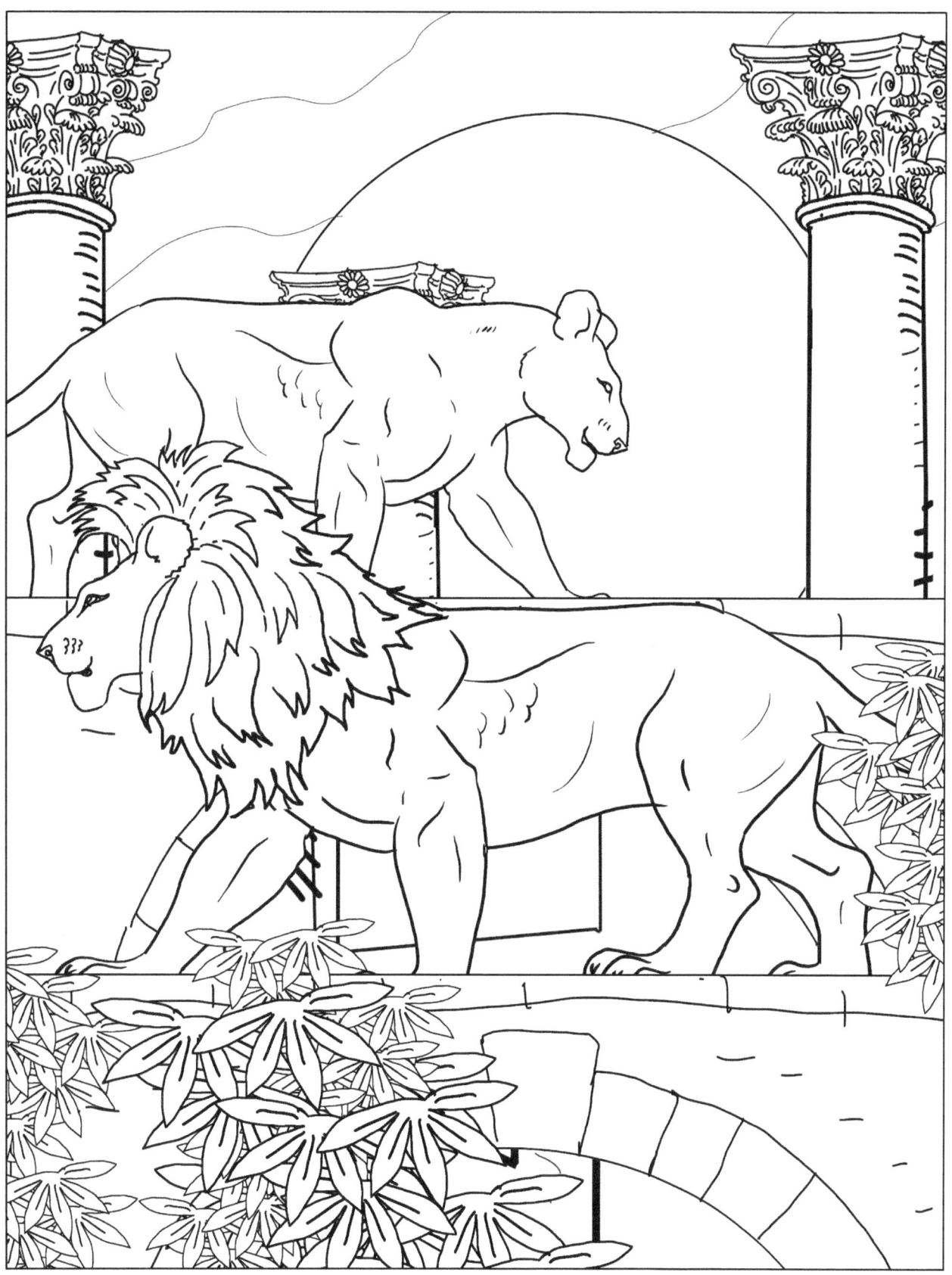

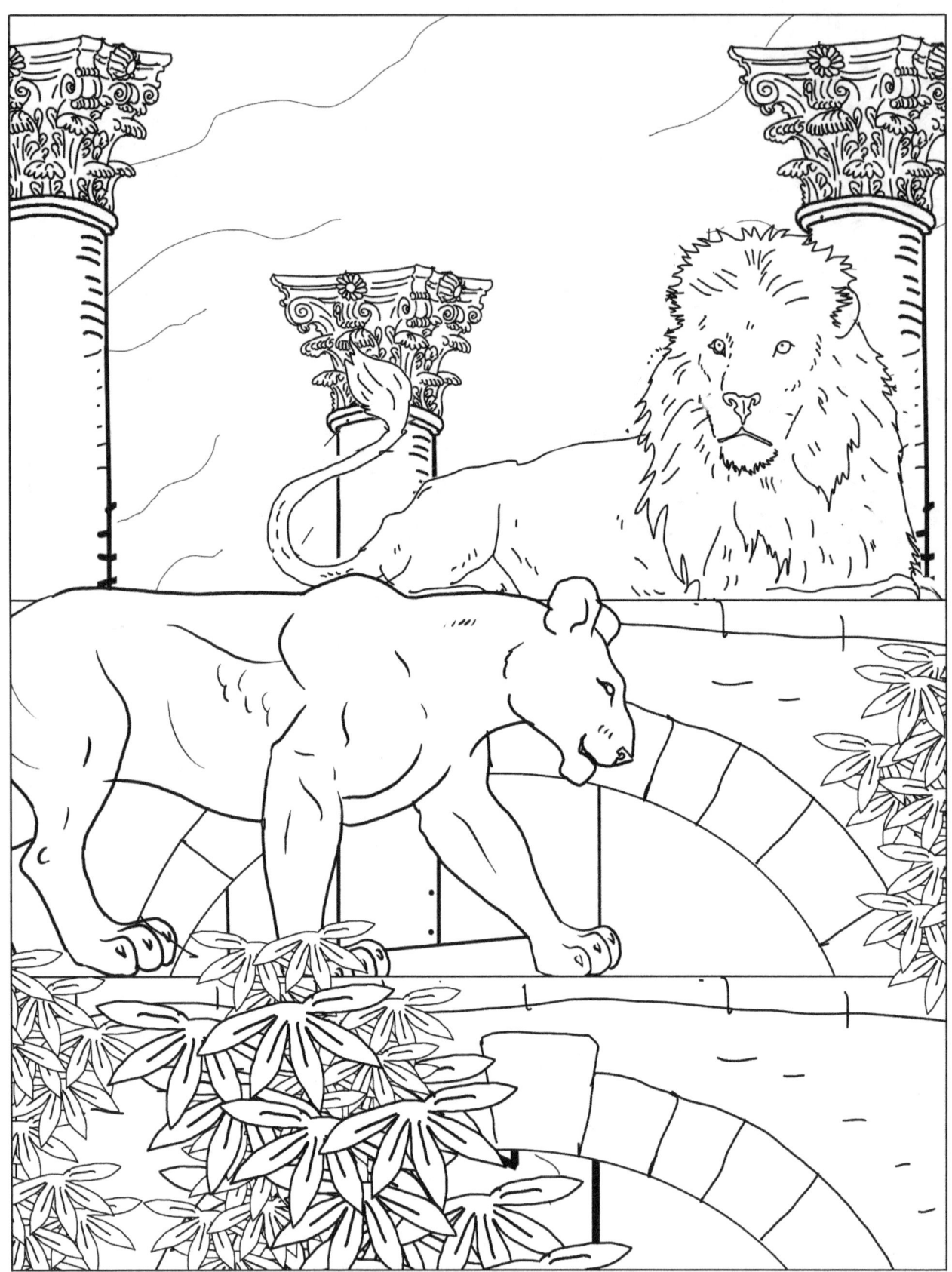

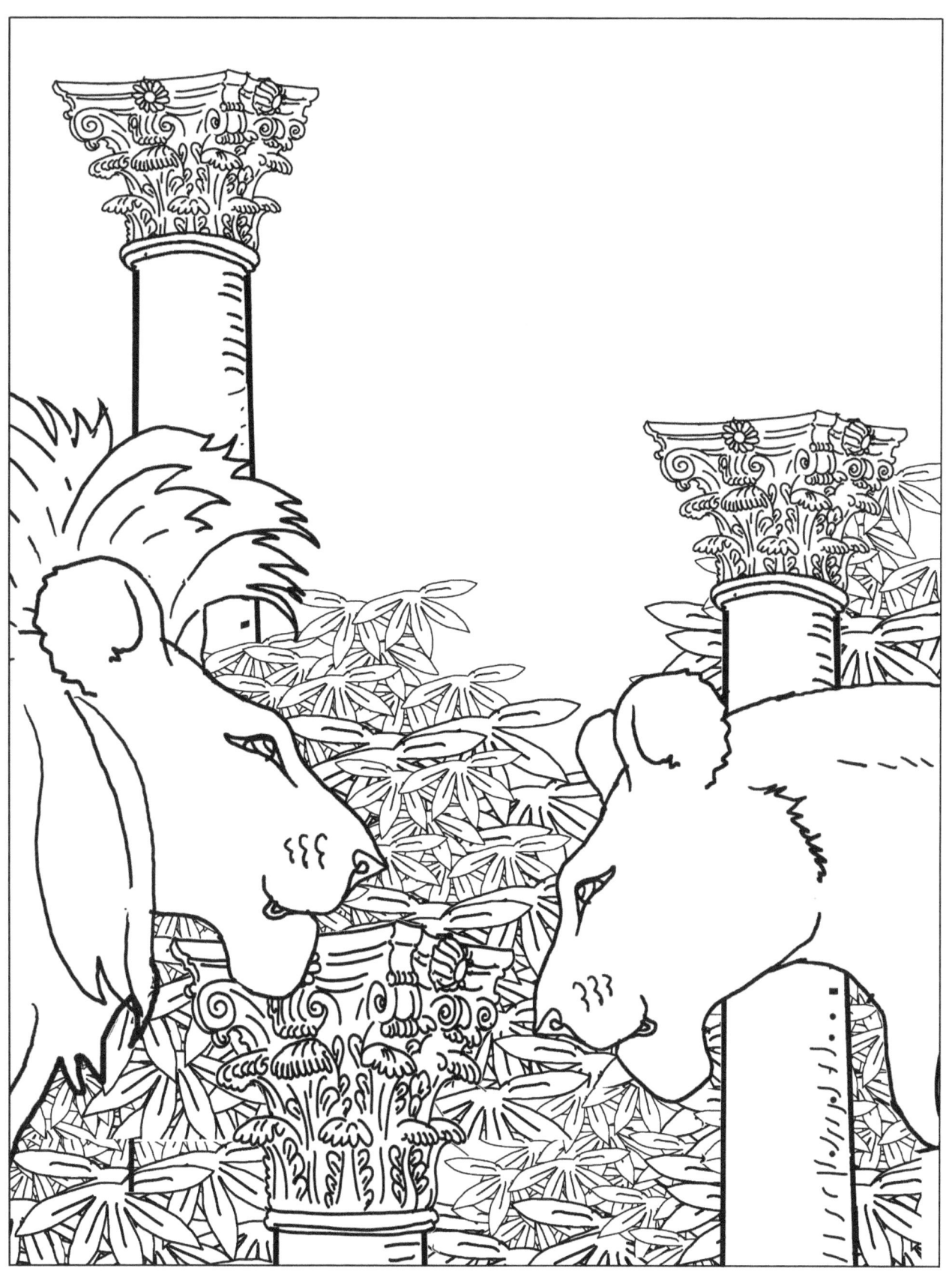

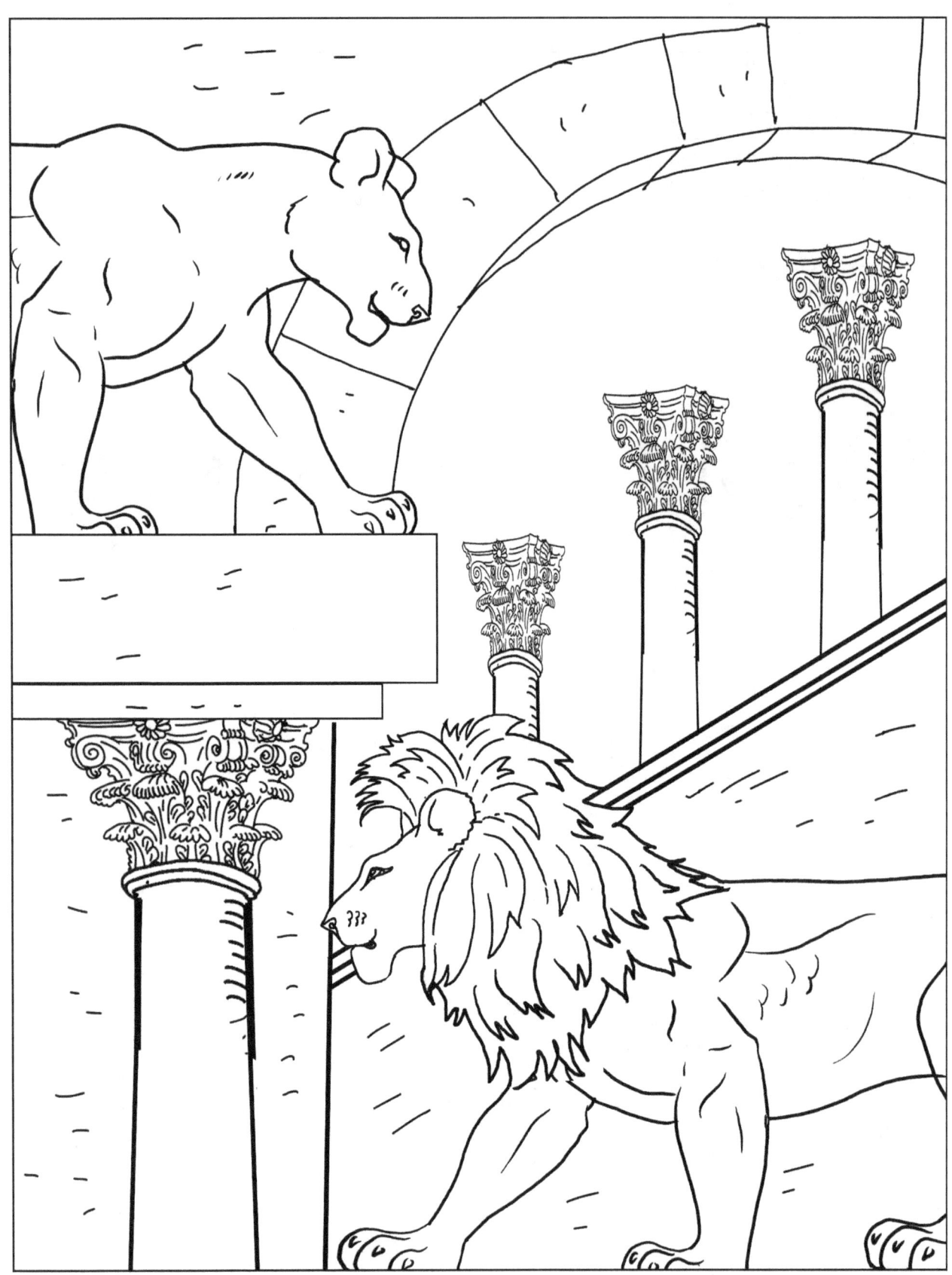

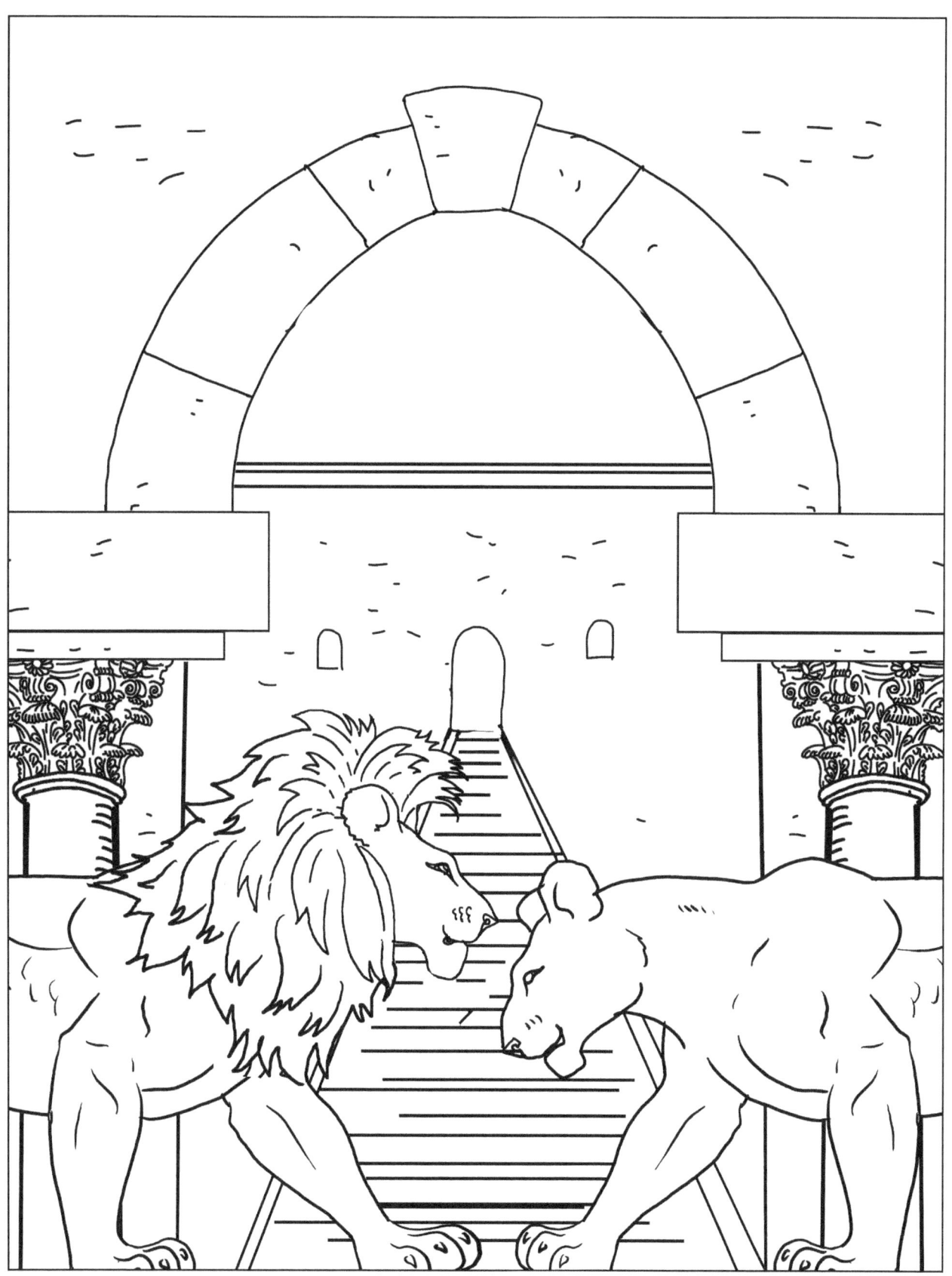

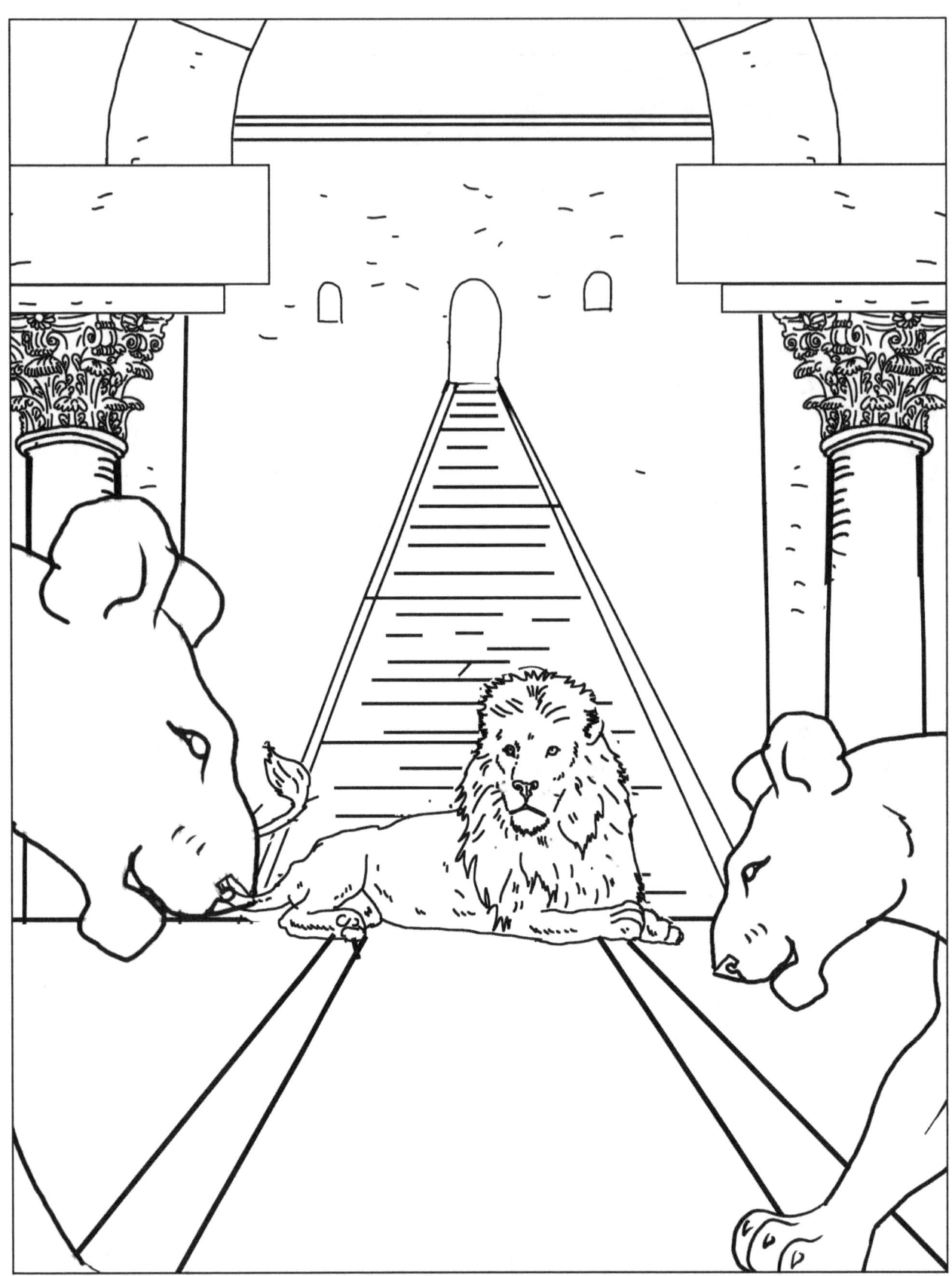

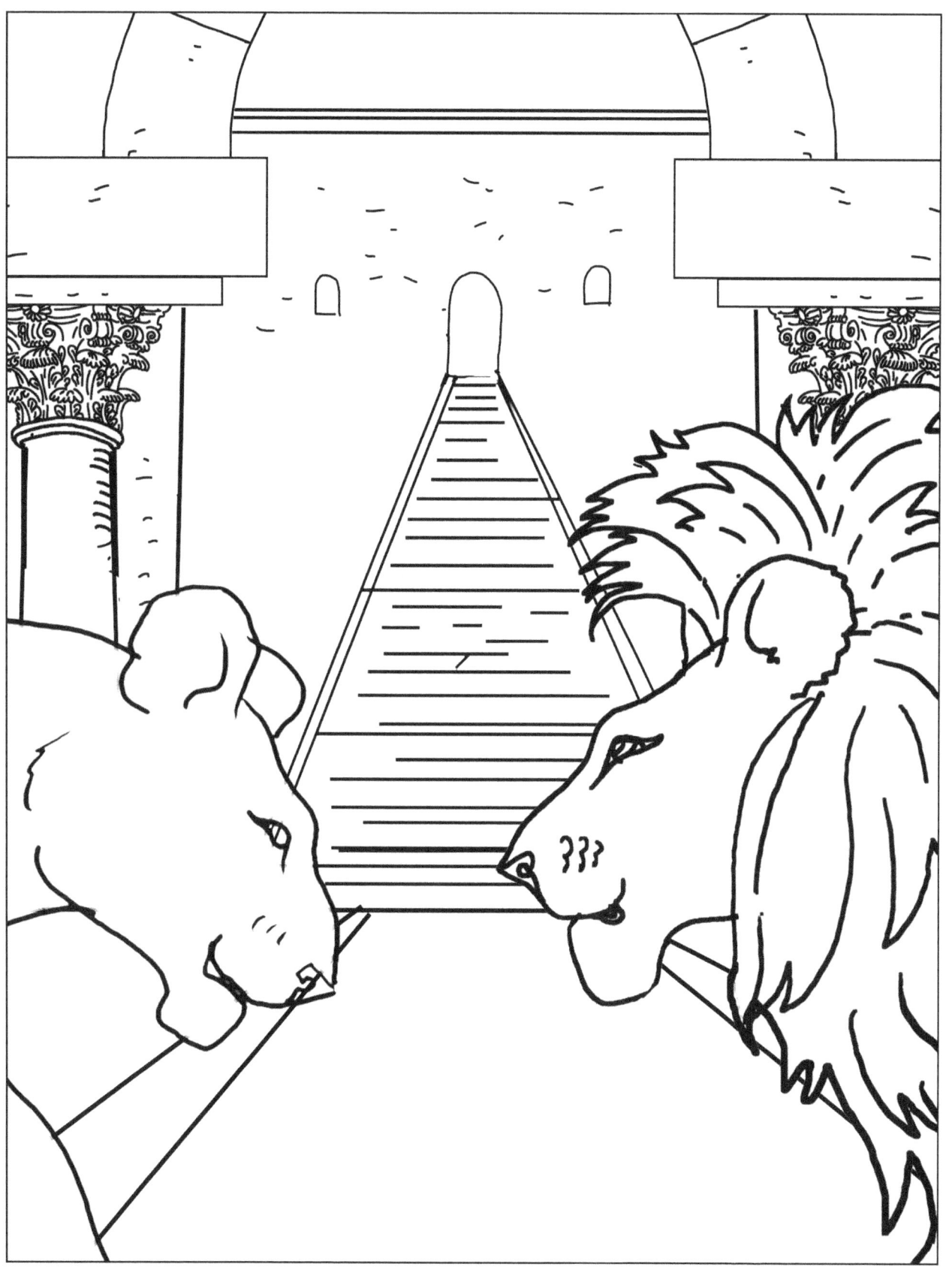

Thank You !

Bambang Wisudyantoro

cannonzhooter@gmail.com

www.ingramcontent.com/pod-product-compliance
Lightning Source LLC
Chambersburg PA
CBHW080532190526
45169CB00008B/3132